DERBY
HISTORY TOUR

First published 2019

Amberley Publishing
The Hill, Stroud,
Gloucestershire, GL5 4EP
www.amberley-books.com

British Library Cataloguing in
Publication Data.
A catalogue record for this book is
available from the British Library.

ISBN 978 1 4456 9338 5 (print)
ISBN 978 1 4456 9339 2 (ebook)

Origination by Amberley Publishing.
Printed in Great Britain.

INTRODUCTION

Derby has a history stretching back over 1,100 years, prefaced by a four-century-long Roman settlement, Derventio, which, after a brief revival during the Danish conquest, dwindled into a small village and now lies within the city's boundary. With the expulsion of the Danes came the refoundation of Derby (as it was thereafter named) on its present site in around 921. It soon flourished, with as many as eight (possibly nine) churches prior to 1086, mills, and from the twelfth century some six monastic establishments, the dissolution of which from 1536 enabled the town's entrepreneurs to flourish. The establishment of the Derby Silk Mill in 1721, Britain's first factory, with all the processes of production gathered under one roof and activated by a common power source, ushered in an age of industrialisation centering more upon luxury goods rather than heavy engineering: silk, porcelain, spar ornaments, fine clocks and gentlemen's carriages.

Yet there can be no doubt that, despite the fame of later developments – the Midland Railway, Rolls-Royce and modern technologies – Derby's finest hour was the age of the Enlightenment, in the later eighteenth century, when groups of highly talented men came together informally in Birmingham, Derby and also in Edinburgh to drive forward the development of modern natural and political philosophy, spurring a broadening of scientific endeavour. Derby contributed John Whitehurst FRS, harboured in his final two decades Erasmus Darwin FRS (allowing him to invent the artesian well in Full Street) and for a while was home to Peter Burdett PRSA, not to mention those closely associated with them: painter Joseph Wright, china maker William Duesbury,

architect Joseph Pickford and many others, some still well known, others undeservedly forgotten.

Not only that, but a substantial portion of the town, rebuilt during those prosperous years, remains, despite the best efforts of the council, although through sheer municipal vandalism we have lost the homes of Darwin, Joseph Wright, both houses associated with England's greatest philosopher Herbert Spencer, and the house Pickford rebuilt for John Whitehurst (earlier owned by John Flamsteed and later where Joseph Wright died) is in desperate peril. The house of William Strutt and anti-slavery campaigner Thomas Gisborne was almost lost too, all going to show that, however glorious the past, and whatever benefits exploiting it could bring, lack of interest and investment in such a heritage allows developers scope to continue chipping away all that makes Derby an unexpectedly agreeable place. Yet, Derby's Civic Society, some important elements of the city council (when in power), Historic England and the national amenity societies have been successful in seeing the wreckers off.

What the reader can see and enjoy by taking this tour is the best of what central Derby has to offer. One hopes that the text that accompanies the photographs will enlighten and that the Civic Society's blue plaques, where they crop up, will embellish.

Using a book like this will, it is hoped, help local people and visitors alike to reconnect with what is a pretty impressive heritage. It is an opportunity not to be missed and if anyone, having read it, feels inclined to take up cudgels on behalf of Derby, they should not hesitate for a second. And if an ally you require, feel free to contact our excellent Civic Society.

KEY

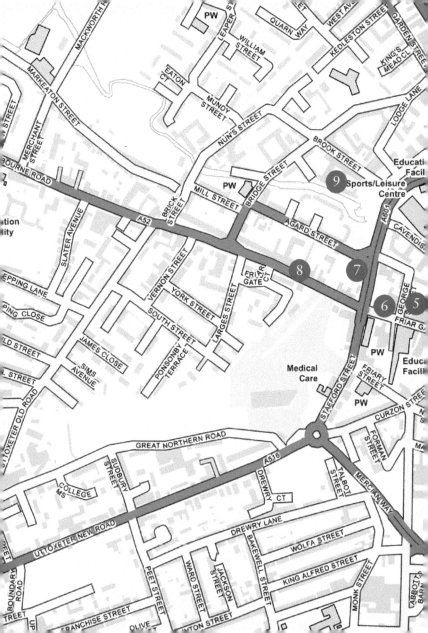

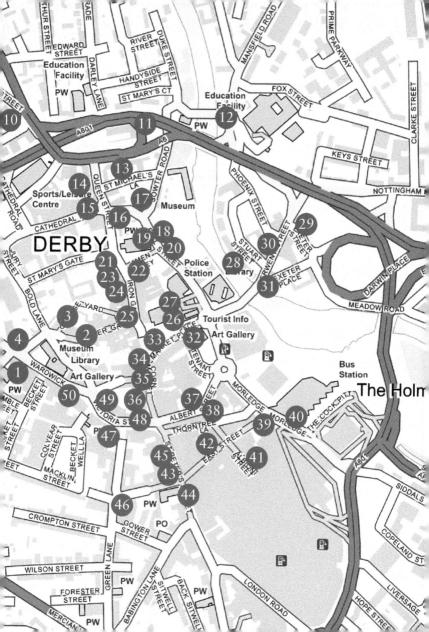

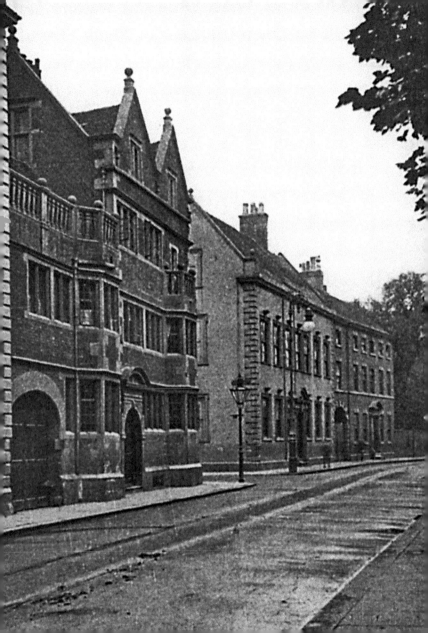

Park in Parksafe, Bold Lane, and proceed via Cheapside to Wardwick.

1. SOUTH SIDE OF THE WARDWICK

A rare view of the south side of the Wardwick before the buildings were shopfronted. The quoins of the *c.* 1694 Mundy (of Shipley) House (Grade II listed) are just visible (left), then comes Grade II* listed Jacobean House of 1611, with Becket Street beyond, across which the latter's façade once stretched before the street was pitched in 1852. The house beyond is an early eighteenth-century rebuilding of a Jacobean original, but the blind end windows have subsequently been removed and rendered over. Beyond that is the Grade II listed Mundy (of Markeaton) House, designed by James Denstone, built in 1767 and now shopfronted. Since the photograph, later nineteenth-century building has taken place beyond it. (Photograph by Richard Keene Ltd, *c.* 1895, Derby Museums Trust L7659)

Cross the road and go through to The Strand via the library passageway. Cross The Strand and walk through the Strand Arcade.

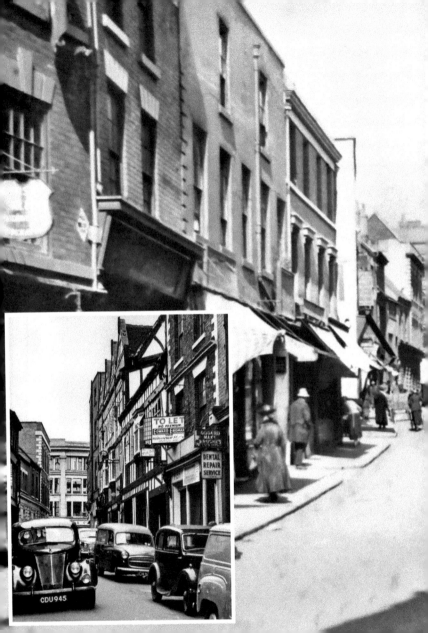

TO LET
NO PREMIUM
EDWARD CROMAK

DENTAL
REPAIR
SERVICE

CDU 945

2. SADLER GATE

Sadler Gate is first recorded in a charter of *c.* 1180, when it indeed had saddlers working there; the last, Potts, closed in the late 1970s. Many of the eighteenth-century façades hide much earlier timber-framed buildings. The narrowness of the street rendered passage acute in the age of the motor car (as inset, with pre-war Ford V8 on the left, Hillman Husky centre and behind a Morris 8 and an Austin A35 van). Since 1967, thanks to the efforts of the Derby Civic Society, the street has been pedestrianised. (*Derby Telegraph*)

Turn left out of the Strand Arcade and proceed to the entrance of Derby Museum.

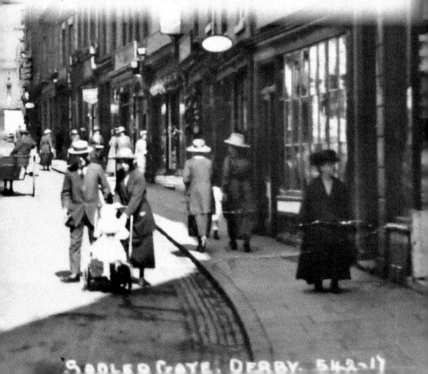

3. SADLER GATE BRIDGE

The bridge over the brook, where Sadler Gate once ran into Cheapside, vanished under the Strand Culvert in 1871, but the nameplate still remains on the Gothic building opposite the museum. The street once consisted of an agreeable agglomeration of early Georgian houses, which were all demolished immediately after the Second World War and replaced by a garage, which itself later became a supermarket, but the site has recently acquired some rather lumpish new shops and offices in 2013, with more planned. (Photograph, *c.* 1930, by C. B. Keene & Co., private collection)

Turn left and follow Cheapside to the Wardwick, then cross over to St Werburgh's Church.

4. CHEAPSIDE CORNER, THE WARDWICK

The north side of the Wardwick, with the museum looming up on the left background. The 1920s Austin Seven is entering Cheapside, negotiating the aftermath of the devastating flood of Sunday 22 May 1932, when the river backed up. Following this, Herbert Spencer's originally rejected 1841 suggestion – a giant barrier on the Derwent south of the town to prevent a recurrence – was rapidly implemented by the council. It never happened again. (Photograph of 22 May 1932, private collection)

Proceed along Friar Gate.

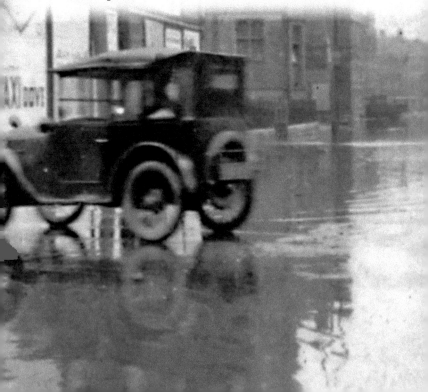

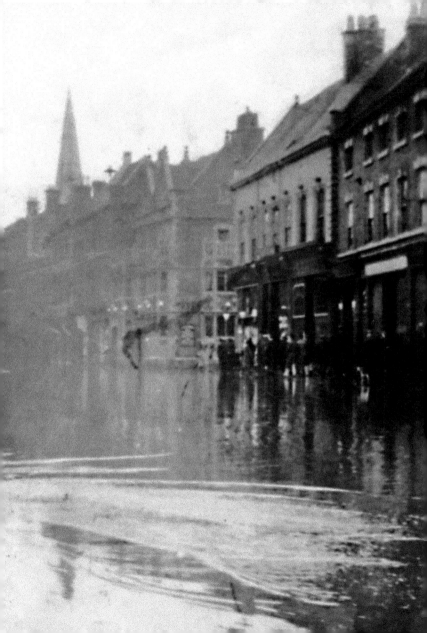

5. GEORGE STREET

George Street was pitched in 1820 to give access to the new gasworks – a semi-demolished portion of which can be seen beyond the stone-fronted cottages built for the workers. The three arches were kept as a feature when a housing association built a new flat complex on the site in the early 1970s, but were inexplicably removed in 2012. The houses all went in the 1970s as well, and were eventually replaced by a neo-Georgian block of flats in 2010. Out of sight to the right, two good Georgian houses happily survive. (Photograph of 1948, Derby Museums Trust L5988)

Proceed further along Friar Gate to the corner of Ford Street.

6. QUEEN ANNE HOUSE, FRIAR GATE

On the car park stood, until 1938, what was known as the Queen Anne House. In truth it was a fraction earlier, built for Alderman Gilbert Chesshyre, from whose granddaughter Kathryn it passed to the Cheneys, and eventually to the solicitor Francis Bassano. It was then divided; part of it was occupied by artist A. J. Keene, a son of the photographer, Richard. The grandest rooms were Elizabethan style on the top floor. It was wastefully demolished for a road widening that did not get done until 2011, after seventy-three years as a car park. (Photograph by Frank Scarratt, 24 March 1938)

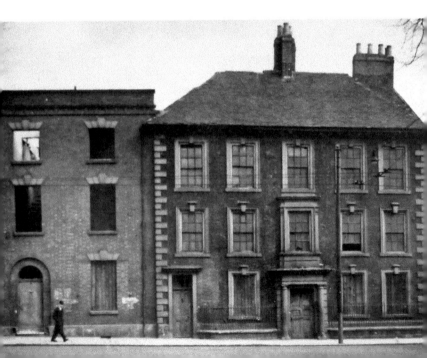

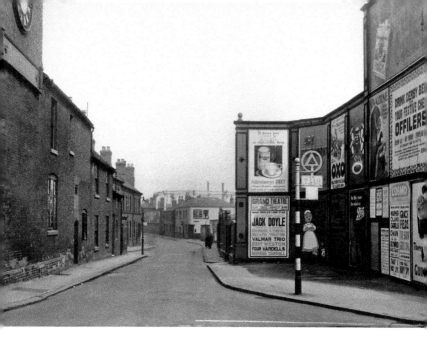

7. FORD STREET

Viewing east down Ford Street, one sees that hoardings mask the soon-to-be-derelict site of Chesshyre's House. Beyond them, a line of cottages has been partly demolished, but the road has yet to be realigned. On the left is the service wing of No. 27 Friar Gate (Grade II* listed), built by Joseph Pickford for John Oldknow in 1778. The turret clock on the gable was then recently installed by antique dealer Frederick Pratt. The white building in the distance is the 1830s Vine Inn, which was demolished in 2017. (Photograph dated 31 March 1938 by Hurst & Wallis Graham Penny)

Proceeding further along Friar Gate, go beneath the railway bridge until you reach Pickford's House Museum.

8. NUNS' GREEN

In 1768, Derby's first improvement commission acquired Nuns' Green – all of the land between Ford Street and Bridge Street on what is now called Friar Gate – and sold the plots for building. This resulted in a superb run of Georgian houses, with four by Joseph Pickford, including the one with a pediment, which he built for himself, and since 1988 has been an excellent museum (Grade I listed). Here, we see beneath the Grade II listed GNR bridge (built by Andrew Handyside in 1876), where the road was lowered in 1904 to accommodate electric trams and, by the time it was taken, trolleybuses. It is wartime, the cars mostly belong to doctors or surgeons, and the iron railings have yet to be uprooted. The London planes were planted (as in London Road) in 1873. (Photograph of April 1941, Derby Local Studies Library)

Proceed through Pickford's House or beside it via its garden and car park (if open; otherwise continue up Friar Gate to Bridge Street, into which turn right and right again into Agard Street and proceed along it until you reach Searle Street), cross Agard Street, turn left and walk along to Searle Street. Turn right and cross the Markeaton Brook via the iron bridge, turning right at the end.

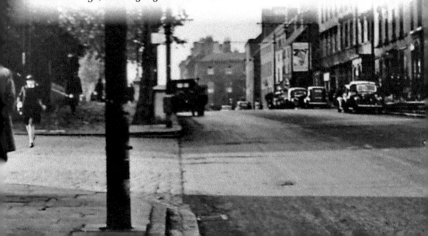

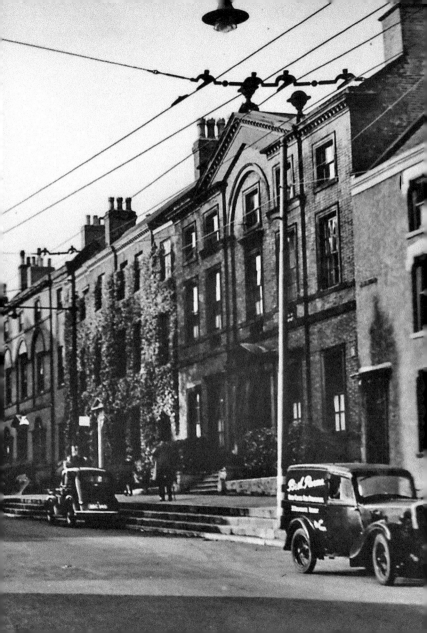

9. BROOK WALK

The iron footbridge across the brook was replaced in the 1990s, courtesy of the University of Derby. While the brook was once open all the way from the Derwent, by 1871 it had been culverted from the river to Ford Street. The area was built up through the release of land by the Third Improvement Commission of 1791. This picture shows Ford Street Bridge in the distance, unculverted, with modest houses on either side. Most of the mills have come and gone since, to be replaced by bland new apartment blocks. The widening to the left is Little Bridge Street. (Platinotype print of a photograph originally taken in May 1855 by Richard Keene; James Richardson)

Proceed along Brook Walk, turn left into Ford Street and left and right into St Helen's Street, walking to the upper end.

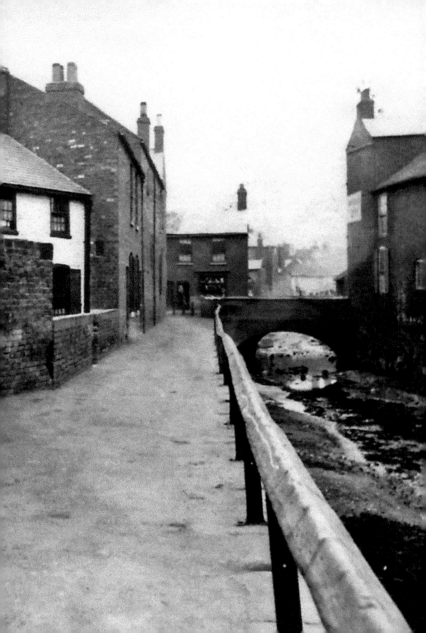

10. ST HELEN'S STREET MARBLE WORKS

A marble works was established on this site, at the corner of St Helen's Street and King Street, in 1802. It was established by petrifactioner Richard Brown (1736–1816), being the site of Old St Helen's House, itself fashioned from the medieval hospital of St Helen (part of the Abbey of Darley) at the Reformation. Here we see the later showroom, with Brown's house behind. Behind the showroom (demolished in 2005 to extend the inner ring road) lie the original works, where the waste heat from a steam engine heated Derby's first public swimming pool from *c.* 1820. (Photograph by the late Don Farnsworth, 1970s)

Cross King Street on the crossing and take the path downhill past St Mary's Church.

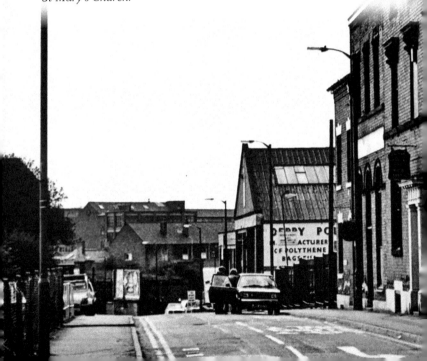

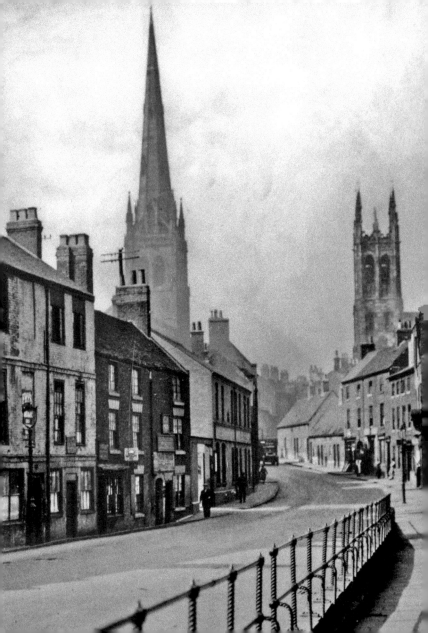

11. BRIDGE GATE

Bridge Gate (the 'gate' suffix is Norse for 'street', a measure of its antiquity) was pitched along the late Saxon town ditch at the same time that the first bridge was built around 1200. The spire is that of St Alkmund's, a minster church founded some 250 years before the Saxon burh. The tower is that of Pugin's St Mary's (1838). The street vanished to build the inner ring road in 1967, leaving just a footpath, now dominated by the towering inconsequence of the plastic-clad Jury's Inn (2009). (Photograph by Margaret Goodey, 1930)

Cross Sowter Road, cross the road to the bridge and turn left onto a path that winds round and under the bridge.

12. ST MARY'S BRIDGE

The first bridge over the Derwent since Roman times dated from just before 1200, and marked the route to Nottingham. It was replaced by the 1788 Improvement Commission – the first chaired by William Strutt – and completed in 1794 by Thomas Harrison of Chester and is Grade II* listed. On this side lies Derby's early fifteenth-century chapel of St Mary-on-the-Bridge (Grade I listed). This is one of six

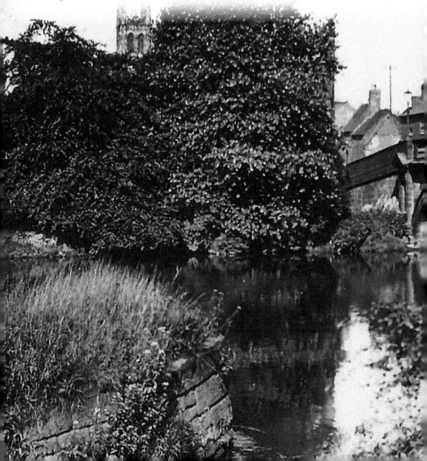

surviving bridge chapels in England, reinstated for worship in the nineteenth century and tactfully restored in 1930. (Photograph of c. 1930 by Margaret Goodey)

Proceed along the path, under St Mary's Bridge and beneath the inner ring road and when you reach the north end of the Silk Mill turn right and proceed across Sowter Road.

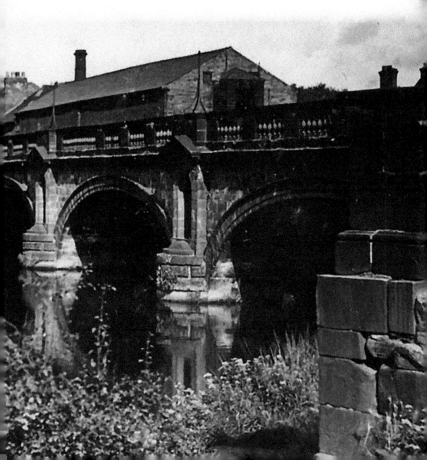

13. ST MICHAEL'S LANE

Its name is derived from the church on the corner of Queen Street and it anciently ran down to a ford over the Derwent called The Causey. It marked the earliest route to Nottingham, predating the bridge. The delightful timber-framed pub was the Grade II listed Nottingham Arms, which was, from its name and position, clearly of very ancient origin. It was unforgivably demolished in 1964 to make way for a car park, although the site was only developed with offices two decades later. (Photograph by Margaret Goodey, *c.* 1930)

Proceed to the top of St Michael's Lane and look half right.

14. SMITH'S CLOCKS, QUEEN STREET

This little house is all that remains of a much larger edifice erected by the father of Revd John Flamsteed (1646–1719), England's first Astronomer Royal. It was enlarged for John Whitehurst FRS by architect Joseph Pickford in 1764. The painter Joseph Wright lived here from 1793 until his death four years later. In 1865, John Smith moved his clockworks here, remaining until 1998, during which time the portion to the left was demolished to improve access to the works behind. The street front was removed in 1924 to allow widening. Here Smith's proprietor Howard Smith's Rover can be seen parked outside. This decaying and unlisted building has been derelict for fifteen years. Yet because of its associations, it is one of the most precious survivals in the city. (Photograph of 1952 by J. E. Howard Smith, Smith of Derby Ltd)

In Queen Street, turn left and proceed to the junction.

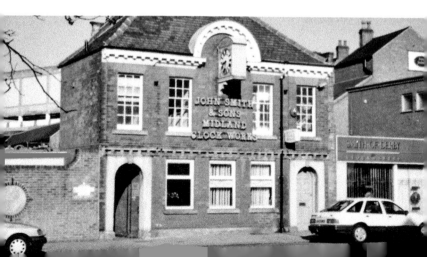

15. CATHEDRAL ROAD AND WALKER LANE

Walker Lane was straightened, widened and renamed Cathedral Road as part of the 1930s Central Improvement Plan. Slum clearance was achieved at the lower end, and C. H. Aslin's handsome baths complex was built adjoining Queen Street, the side of which can be seen here. The former Bluecoat Almshouses on the left (long secularised) were swept away in 1929 by Messrs Kennings to expand their motor emporium, built by Wilcockson & Cutts of Chesterfield, which is just visible on the far left. (Photograph dated 14 March 1938, probably by C. B. Sherwin)

Facing you at this intersection is the Old Dolphin.

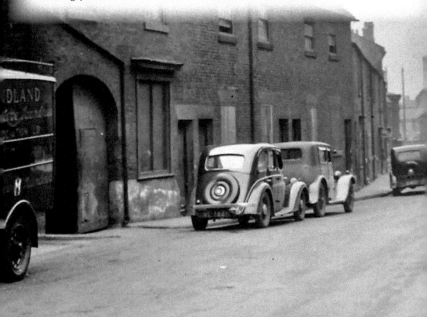

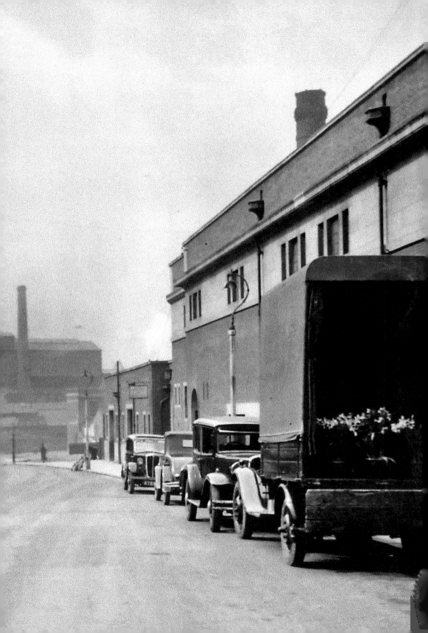

16. THE OLD DOLPHIN, QUEEN STREET

The name of the inn has religious overtones in keeping with its claim of foundation by the College of All Saints in 1530. The building is early seventeenth century and Grade II listed, despite faux timbering painted on the overlying stucco in the early image. After the war, the stucco came off, the original timbers rotted and had to be replaced, and the range facing Full Street was heavily truncated. It is one of the few city centre pubs to retain actual rooms. (Photograph by Margaret Goodey, *c.* 1930, courtesy of Mrs. P. Cannon)

Go into Full Street.

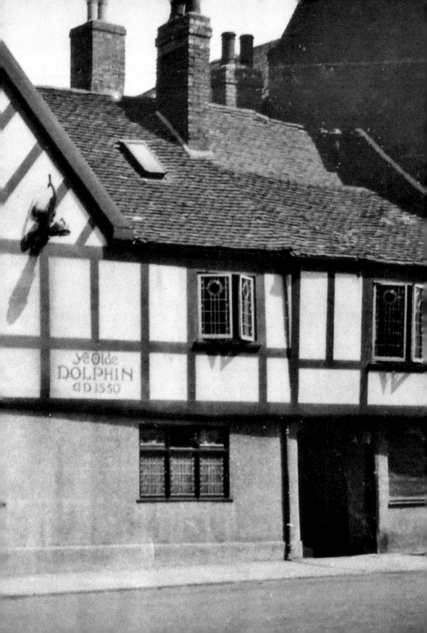

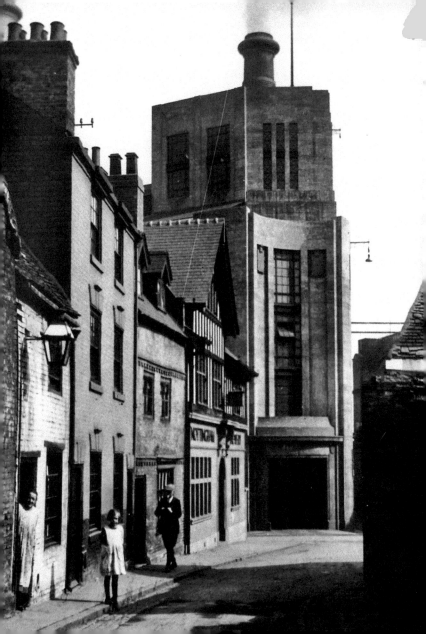

17. NANNY TAG'S LANE, FULL STREET

The upper end of Full Street was anciently known as Nanny Tag's Lane, or Alderman Hill. It was widened in 1944 and formally united with Full Street when the cottages on the left were demolished, leaving only the rebuilt Silk Mill Inn. In the 1920s, where it turned south as Full Street, was built an art deco extension to the Municipal Power Station. The power station went in 1972, to be replaced by a huge electricity substation hidden behind an unnecessarily high wall. Peeping over the top is the bell tower of the Silk Mill (built in 1718–21 and Grade II listed). This was rebuilt in 1821 and again in 1910 after fires. (Photograph by Margaret Goodey, 1930)

Proceed along Full Street to the east end of the cathedral.

18. FULL STREET

Full Street is ancient and runs parallel to the river. It was fashionable in the seventeenth century, when Bess of Hardwick endowed almshouses opposite the east end of All Saints (now the cathedral). These were rebuilt, as seen here, by Joseph Pickford in 1777 (inset). In 1893 they were demolished to make way for the Municipal Power Station. Today, the east end of the cathedral (1971) now obtrudes, the rebuilt Silk Mill Inn stands out and the windowless tower of the Jury's Inn dominates all. (Photograph by Richard Keene, *c.* 1892, subsequently made into a postcard, private collection)

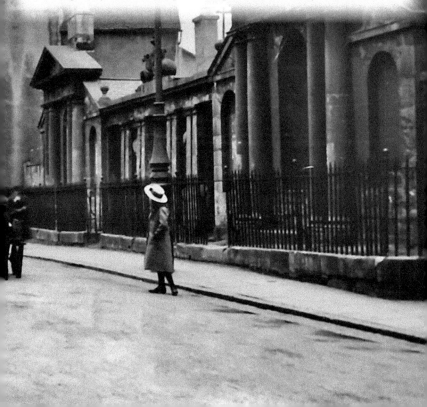

19. VIEW SOUTH OF FULL STREET

The power station of 1893 was demolished in 1972 and the council then did a brave thing: they left the site green, giving the cathedral and Silk Mill room to breathe. The downside was that the same year the surviving Georgian buildings on the right were removed to make way for a multistorey car park. (Photograph of October 1959 by Frank Scarratt)

Go up Amen Alley to Iron Gate.

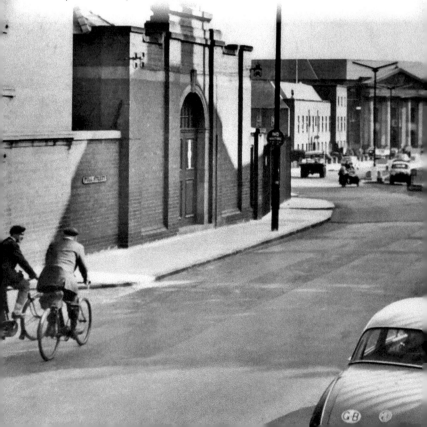

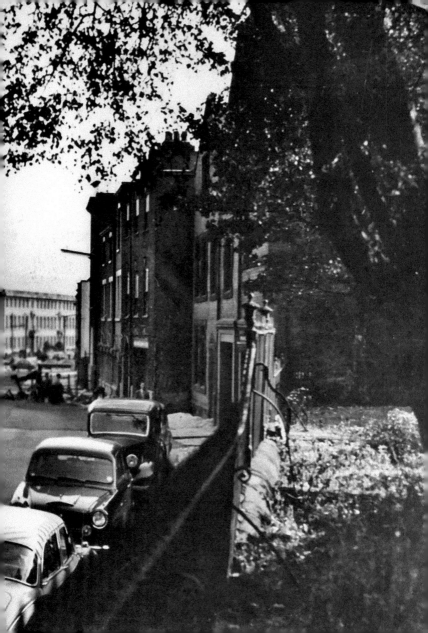

20. DERBY CATHEDRAL, QUEEN STREET

The interior of the former All Saints' Church nave, built by James Gibbs in 1723–25 and Grade I listed, is a tour de force of light and airiness, although here it is seen after a particularly insensitive reordering by Julian Young in 1870–73. The celebrated wrought-iron screen by Robert Bakewell (1682–1752) can be seen decorated for Harvest Festival. In 1969–71, the Venetian window was removed and the church extended eastwards by Sebastian Comper in order to create a retro-choir, song school and meeting rooms. (Photograph by Richard Keene, *c.* 1875)

Now look beyond the cathedral back the way you came.

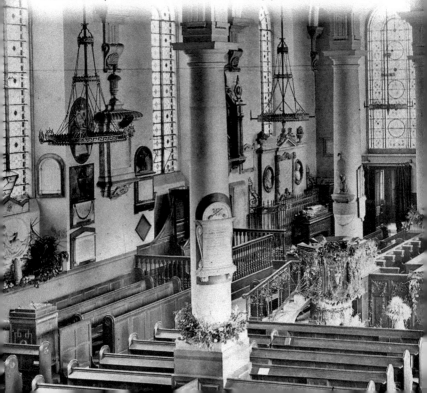

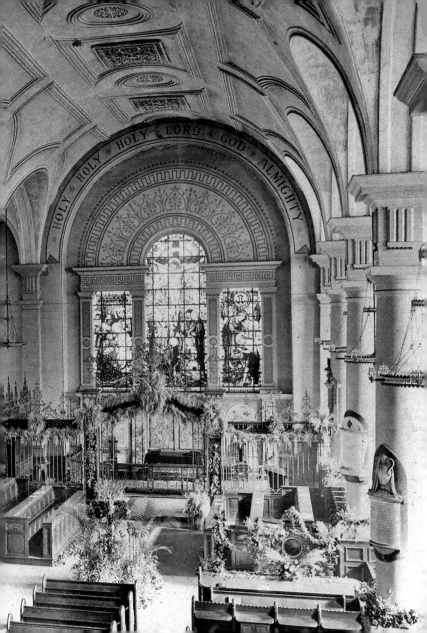

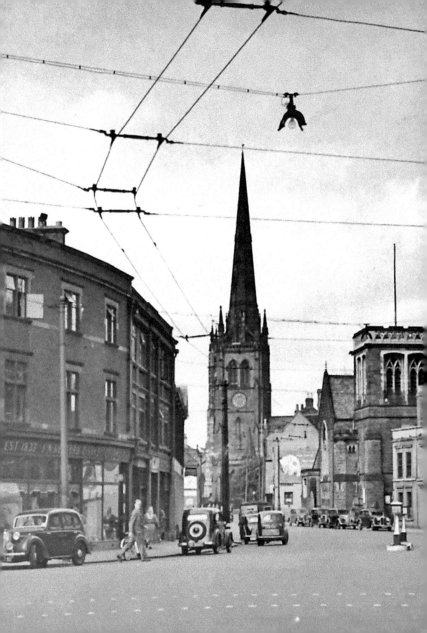

21. IRON GATE AND QUEEN STREET

The 1838 tower of Pugin's St Mary's Catholic Church was, until 1967, hidden behind the spire of Henry Stevens' St Alkmund's Church (1846). In between St Michael's, built by Henry Stevens in 1858 and Grade II listed, remains in the centre of the scene, with the tower of the cathedral to the right. Also gone are the trolleybus wires. The building to the left on the corner of St Mary's Gate has recently been heightened. (Photo stamped on reverse, 'Air Ministry, December 1940')

Now about-turn.

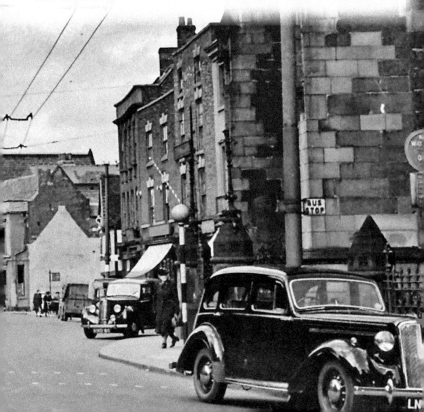

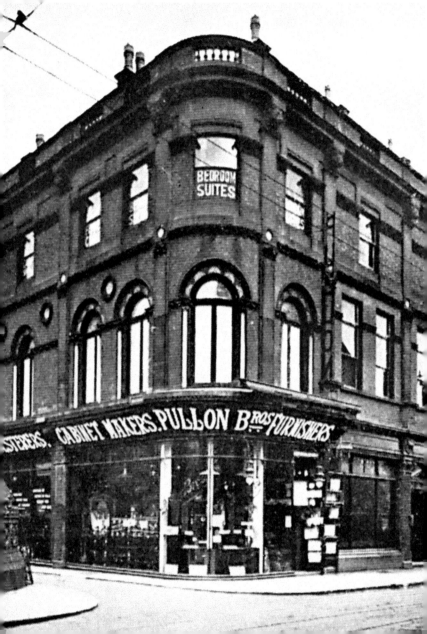

22. AMEN ALLEY, CORNER OF IRON GATE

As part of the 1866 widening of Iron Gate, the whole east side was replaced, the cleared plots being sold by tender. The one on the corner of Amen Alley was designed by Benjamin Wilson. His articled clerk, Frederick Woodward, wrote in 1870: 'We have got the largest job of the lot, the rebuilding of the houses at the corner of Amen Alley and a heavy job my governor made of it. That which should have been the handsomest building in the street has turned out to be perhaps not the worst, but certainly not the best ... I do not aspire to the honour of having had a hand in the making of it...' (Photograph from a 1909 trade directory)

23. SOUTH VIEW OF IRON GATE

The 1866 widening of this street was the first of a series lasting until the 1920s. Here in May 1855, the street is more or less as it was in the 1750s, when John Whitehurst FRS and the young Joseph Wright lived virtually side by side. Whitehurst resided in the house to the left of the small double-gabled building, which was later occupied by photographer Richard Keene. (Photograph by Richard Keene, Derby Museums Trust)

Proceed to the bottom of Iron Gate and look back.

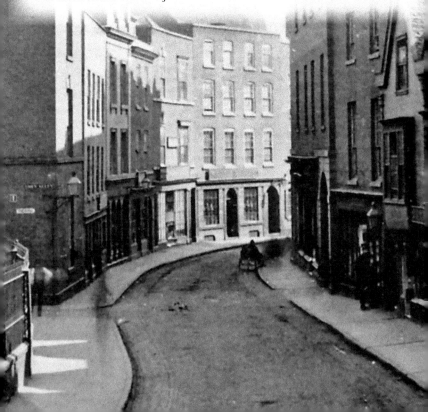

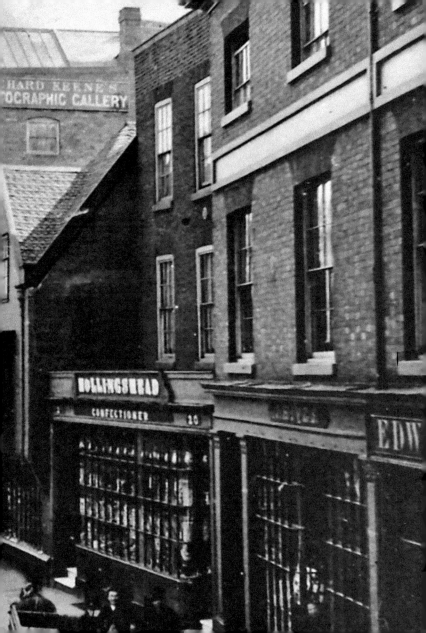

24. VIEW NORTH OF IRON GATE

A late Victorian view of a street that in the fourteenth century actually had a concentration of ironmongers and smiths. The building nearest the left (part of the birthplace of the artist Joseph Wright ARA) was replaced in 1906 by an Arts and Crafts shop/office. The building beyond was Crompton & Evans Union Bank, later the NatWest (built by J. A. Chatwin in 1880 and Grade II listed) and then converted into a pub called The Standing Order in 1992. The 1530 Perpendicular tower of the cathedral, built by John Oates in 1511–31 and Grade I listed, dominates. (Photograph of 1894 possibly by Richard Keene Jr, Derby Museums Trust L.166)

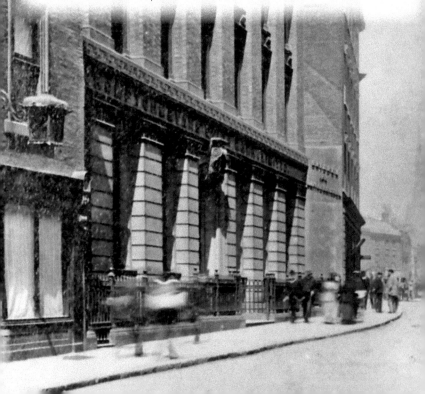

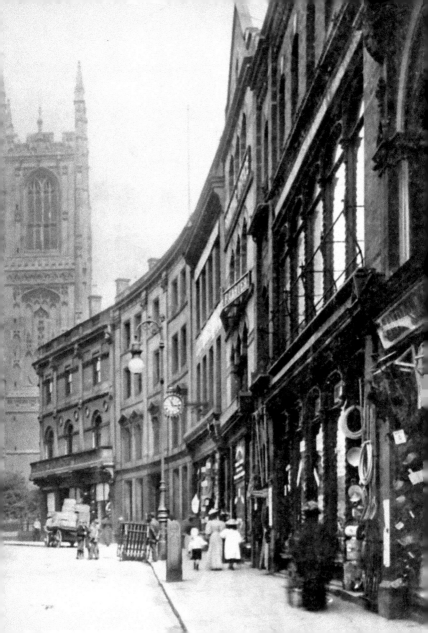

25. MARKET HEAD, MARKET PLACE

This is a view of Barlow, Taylor & Co.'s drapery store on the west side of the Market Place, an area known from time immemorial as Market Head. George Beswick founded the store nearby in 1844. It became Beswick and Smith a decade later and was taken over by John H. Barlow in the 1880s, when the first-floor display window, plate glass fenestration and cresting were added to the eighteenth-century building. Now it is an Australian-themed pub called Walkabout. (Old photograph from a 1909 trade directory)

Now turn eastwards towards the Tourist Information Centre.

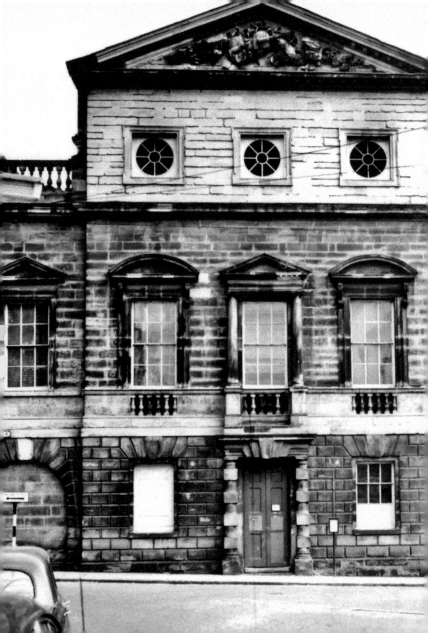

26. ASSEMBLY ROOMS, MARKET PLACE

A combined town and country assembly rooms was built in 1763 to the designs of Washington Shirley, 5th Earl Ferrers, and Joseph Pickford. Grade II listed, the neoclassical interiors were by Robert and James Adam. In 1963, a minor fire prompted demolition of all but the façade, but the architect of the replacement building, Sir Hugh Casson, refused to incorporate the old façade into his overbearingly brutalist design, despite having been requested to do so, so it went to Crich Tramway Museum instead, where it may still be seen. (Photograph of c. 1962, possibly by Frank Scarratt, Derby Museums Trust)

Go underneath the present Assembly Rooms to reach the pedestrian crossing in Full Street.

27. HORSE & TRUMPET INN, FULL STREET

This gloomy unprepossessing void was once the south end of Full Street, which turned right and fed narrowly into the Market Place. On the inside of the curve was the Horse & Trumpet (built in 1761 and closed 1967), and next to it, the taller County Assembly Rooms (built in 1713–64, later a china showroom). Opposite was the side of the later Assembly Rooms (*see* previous spread). This was all swept away in 1970/71 in order to build the current Assembly Rooms and attached car park. Today, the scene is ugly and unrecognisable, although one can still reach the Market Place from Full Street – just. (Photograph by C. B. Sherwin, 1926)

Proceed across Full Street, turn left go past the Premier Inn and turn right.

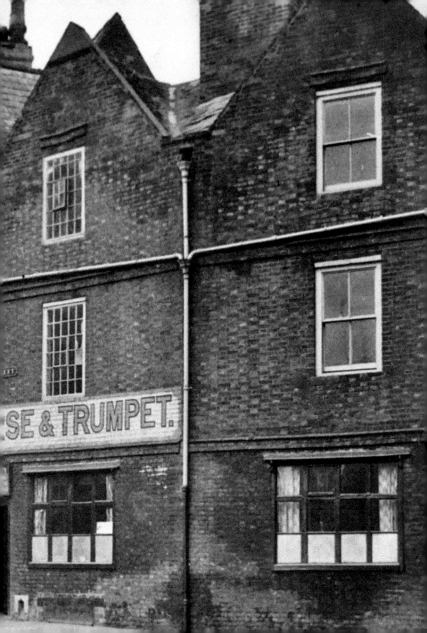

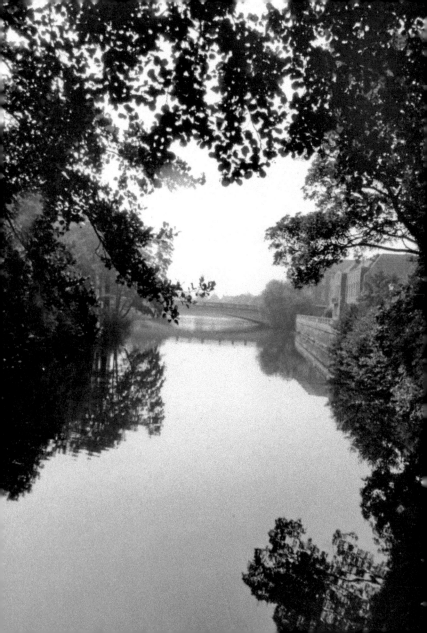

28. THE DERWENT

Seen here one limpid morning in 1978 from the Silk Mill, giving an entrancing view south down the limpid and unruffled river. Apart from Exeter Bridge (designed by C. A. Clews in 1929), all is trees that almost hide C. H. Aslin's fine river façade of the 1933, Grade II listed magistrates' courts, now restored as offices. Today there are oversized ugly flats opposite the new swing bridge and now the far view is compromised by the grim outline of Riverlights, lying behind Aslin's Council House (built in 1938–47).

Proceed beside the river and mount up to Exeter Bridge, cross it and turn right into Exeter Place. Follow this to its end and turn left.

29. EXETER STREET

This handsome row of Regency houses of around 1816 is Exeter Terrace. At the south end, on the corner with Exeter Place, survives the Exeter Arms, which is still one of Derby's most satisfying pubs (albeit that its sign today displays the arms of the city of Exeter, not those of the marquess, from whose ancestors' pleasure grounds the area took its name). In the house on the extreme right was born, in 1820, England's greatest philosopher, Herbert Spencer. He died in 1903 and it was marked from 1905 by a modest stone plaque over the door. As with Spencer's childhood home in Wilmot Street, it was wantonly demolished when the inner ring road was being built. Thankfully the inn survived with a blue plaque put up in Spencer's memory in 2014 by the council and Derby Civic Society. (Photograph by Frank Rodgers, 1946)

30. DERWENT STREET EAST

Derwent Street East traverses Canary Island to the junction with Nottingham Road. The large gabled building is the former Liversage Arms, centrepiece of the Liversage estate, built by Alexander MacPherson in 1898–1901 – one of the manifestations of the city's oldest and richest charity. Unfortunately, in 1968–71, the new inner ring road cut through the entire area, running along the line of the

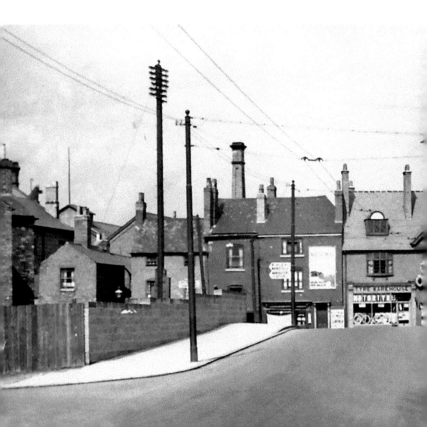

former canal arm but 12 feet above ground level, in front of the pub and its accompanying houses on a concrete viaduct. A car showroom is being built on the right (replaced in the 1970s and again, imminently, by a ten-storey tower block), but the fine moderne NatWest building, designed by Naylor & Sale in 1938 for Messrs Harwood, has yet to be started on the left. (Photograph of 1935 by Frank Scarratt)

Proceed along Derwent Street.

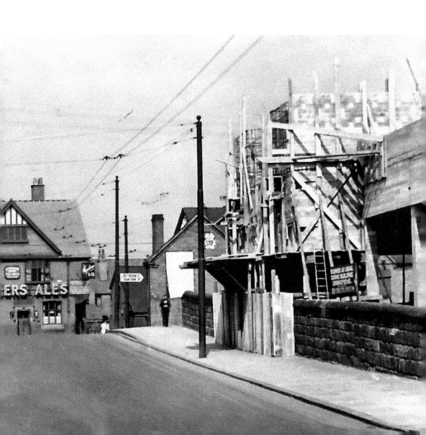

31. EXETER BRIDGE

Derwent Street leads to the Market Place across the Derwent via Exeter Bridge (designed in 1850 by Samuel Harpur, Borough Surveyor, which was named after the eighteenth-century landowner of Canary Island – the land on the river's east side, Brownlow Cecil, 8th Earl of Exeter). In 1904, it acquired tramlines, which made it hopelessly constricted, leading to the building of the present, much wider bridge in 1929. The buildings on the far side (including the shot tower, built in 1809 and demolished in 1931) were swept away to make room for the Council House. (Photograph by C. B. Sherwin, 1926)

Proceed past the Council House across Corporation Street.

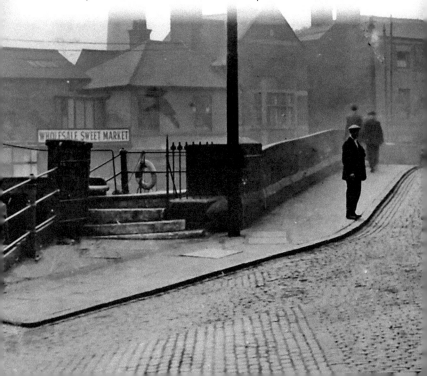

WHOLESALE SWEET MARKET

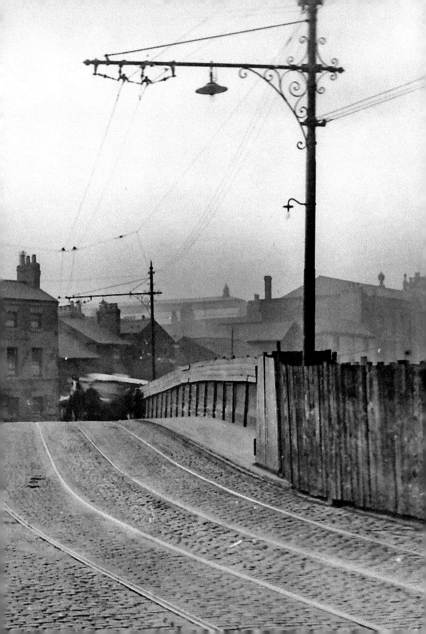

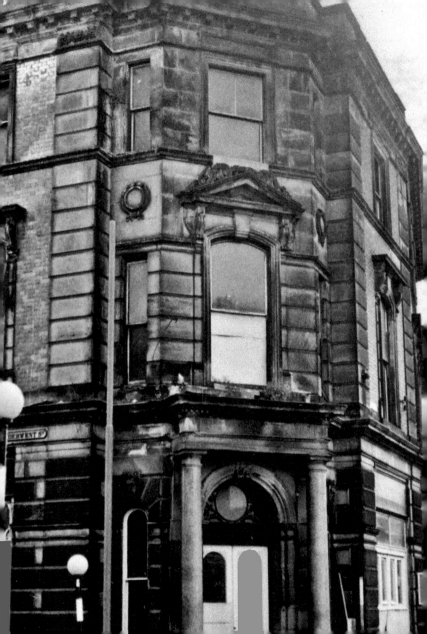

32. TENANT STREET

To the left of the Guildhall, as one looks at it, Tenant Street runs southwards. On the Market Place corner from the 1860s was Britannia Buildings (locally 'Philipson's'), designed by Benjamin Wilson, whom we met in Amen Alley, always a pedestrian architect. It was destroyed in the early 1980s to make way for a five-star hotel that never materialised. Instead, in 2008, the Quad Arts Centre was opened, architecturally *passé* and pretentious, teetering on its wonky piloti, a councillor's ego-trip, taking its architectural cue from the awful Assembly Room and not the modest Georgian buildings beside it. Yet as a venue, it has proved a modest success. (Photograph of *c.* 1972 by R. G. Hughes)

Proceed further along.

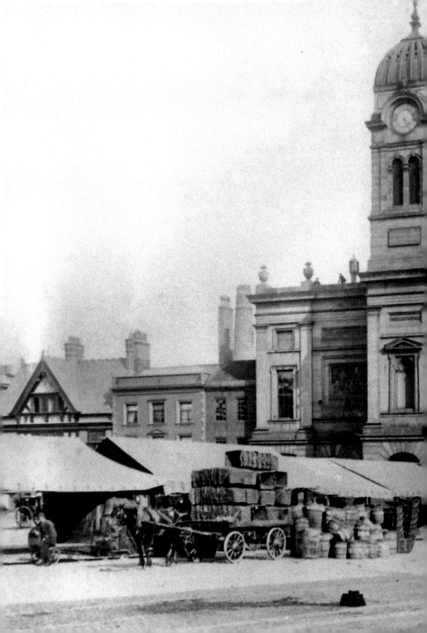

33. THE GUILDHALL

Archaeology has established that Derby Market Place came into being around 1100. A guildhall lay in the middle of the area from at least the fifteenth century, but in 1828 Matthew Haberson designed a neo-Greek guildhall for a new site on the south side. This burnt down very spectacularly on Trafaglar Night, 1841. It was replaced by the present edifice, reusing parts of its predecessor, and was designed by Henry Duesbury, built in 1842 and Grade II listed. (Photograph by Richard Keene, *c.* 1888, Derby Museums Trust L58)

Proceed into Corn Market and look towards Iron Gate.

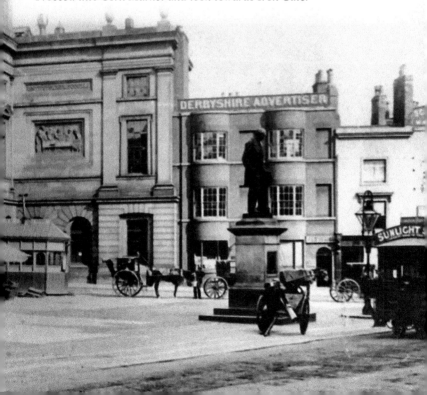

34. CORN MARKET LOOKING NORTH

Barlow Taylor moved across to the north side of the Market Place in 1925, into a new store (above right) by Naylor & Sale. Closed since the 1980s, the building is now divided between a café-bar and a betting emporium, with flats above. The Market Place itself was a car park when the original photo was taken, ringed with trolleybus wires. Today it is cluttered up with plants and from 1990 a water feature by Walter Pye. (Photograph, probably by Scarratt, dated 1947)

About turn and look south.

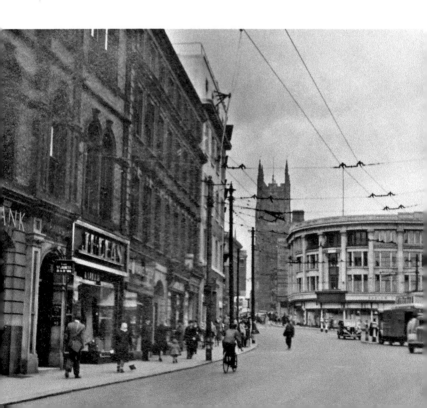

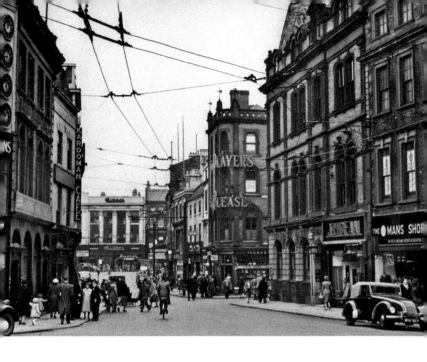

35. CORN MARKET

The ancient north–south route through Derby proceeds south via Corn Market, seen from here in 1959. In the 1860s, a consortium widened St James's Lane, knocking down all the buildings from the right-hand side to the Gothic four-storey one. Their architect was the prolific George Henry Sheffield (1843–82). The glass building now on the left was built as Williams & Glyn's Bank in 1973, replacing John Smith & Sons' clock shop, with its four clock dials showing times around the world. Trams and trolleybuses have come and gone (1880–1934, 1932–67), not to mention the superb Allard. The street was pedestrianised in 1990. (Photograph of 1959 by Frank Scarratt)

COXS VAUL

36. THE TIGER, CORN MARKET

Opposite the end of St James's Street stands a once-fine Palladian house, attributed to Joseph Pickford and built in 1764 (Grade II listed), for Sir Willoughby Aston, 5th Baronet MP. In 1770, it was converted into a coaching inn called The Tiger, which continued until 1815, at which time it moved to a building in the yard behind, and the premises were let as shops. At some stage prior to 1866, the balls were removed from the parapet; later, the pediment was altered and stuccoed, three windows being inserted on the right side of the first floor. In the nineteenth century, the police lock-up lay behind the building through the arch, which is still called Lock-up Yard, but previously Tiger Yard.

Either proceed up Lock-up Yard, enter the Market Hall, turn right and proceed to the south entrance, or if the Market Hall is closed, walk down Corn Market and turn left at the end into Albert Street.

37. OSNABRÜCK SQUARE

The Grade II listed Market Hall, built by Robert Thorburn and Edwin Thomson in 1864/65, was created in the same spirit as the Corn Exchange and its south end, Mill Ground, looked over Albert Street (itself created by culverting the brook in 1848). Shacks serving snacks, newspapers, etc., appeared on Mill Ground but in 1984, the shacks, which included a superb redundant cabbies' rest (foreground), were swept away to be replaced by brick imitations. The area was renamed Osnabrück Square in honour of Derby's German twin city. Attempts to save the cabbies' rest for the museum were rebuffed. (Photograph by Raymond's Agency for the *Derby Trader*, 1973, Derby Museums Trust)

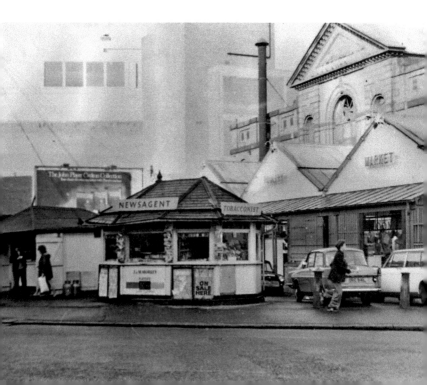

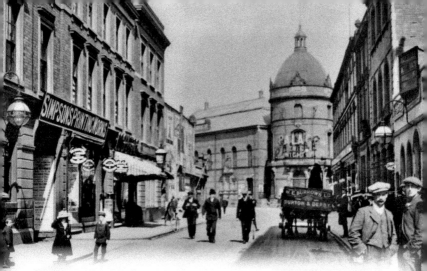

38. CORN EXCHANGE, ALBERT STREET

The 1860s saw a municipal burst of tidy-mindedness, with an attempt to get the three markets – beast, corn and general – off the streets and under cover – hence the Grade II listed Corn Exchange (designed by Benjamin Wilson in 1861/62) in the newly pitched Albert Street. Hardly inspired architecturally, it had coloured-brick banding, a windowless ground floor, a huge ornamental drinking fountain and decorative cresting. Yet it failed to pay its way and was soon converted to a variety theatre and then in 1921 to a *Palais de Danse* by W. Champneys and Grey Wornum. This, too, failed and in 1928, the *Derby Daily Telegraph* took it over, put in ground-floor windows and printed their papers there for nearly sixty years. Today it is offices with its original staircase and cresting removed and an extra storey in the dome. (Photograph by C. B. Keene of 1922, Derby Museums Trust)

Proceed along Exchange Street, turning immediately left into Thorntree Lane, down which proceed until you reach its end, turning right to the end of East Street.

39. THE MORLEDGE

Morledge is another ancient thoroughfare, dualled for the Central Improvement Scheme in 1935. The scheme also provided for the Council House (background), open market (designed by C. H. Aslin in 1933) and envisaged much more, but for the Second World War. East Street is now pedestrianised and the open market swept away for a new Crown Court in 1988, which entirely hides the south front of the Council House. Note the Municipal Power Station, Full Street (rear left), in all its ugly glory. (Photograph by Frank Scarratt, *c.* 1946)

Look in front of you and to your right.

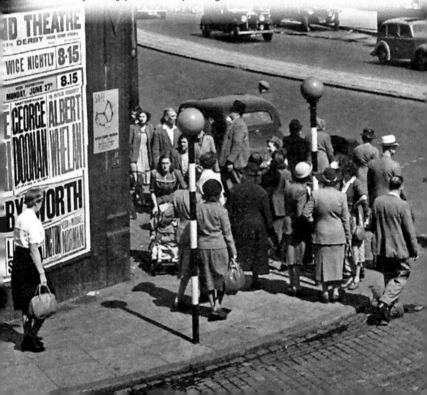

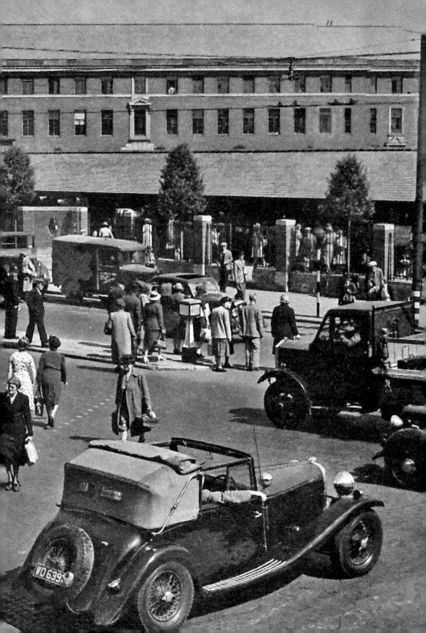

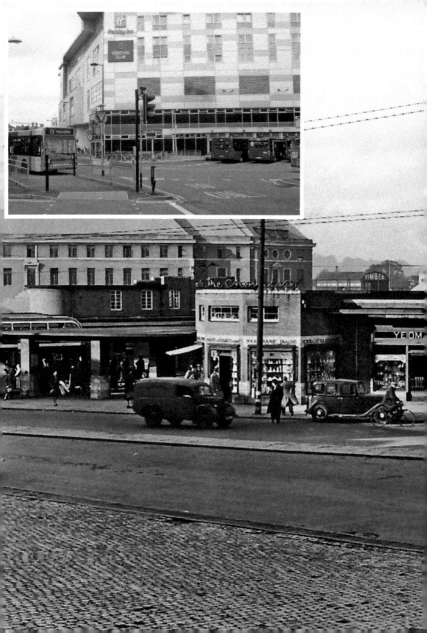

40. THE BUS STATION

Part of the Central Improvement Scheme of 1932, a somewhat restricted site south of the Open Market was reserved for a new bus station. This was designed with parabolically planned platforms to fit the site by Herbert Aslin and opened in 1933. It had an art deco rotunda nearest the Morledge, seen here, containing a restaurant and ticket office with a matching administration block behind. Latterly, it all became very run-down but was listable and capable of effective refurbishment, but the scheme that produced the so-called Riverlights development wanted the site, so promised a new bus station (inset). Its grey metallic elevations are indescribably dreary and cheap looking. (Photograph of 1939, photographer unknown, possibly Scarratt, private collection)

Turn into East Street and proceed to the intersection.

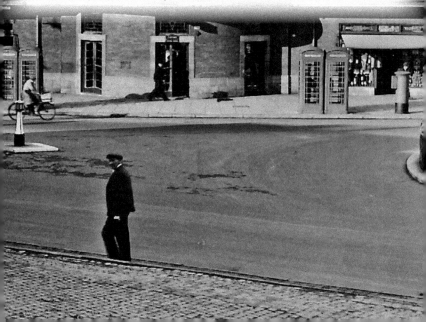

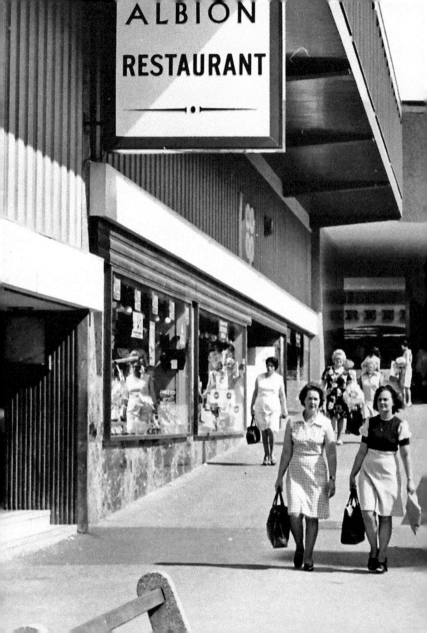

41. ALBION STREET

Albion Street once defined part of the bailey of an adulterine castle from the Anarchy period (1135–54). By the early nineteenth century it led to a complex pattern of mean streets and early terraced housing. This was all swept away in 1969–72 to build a shopping complex of unmitigated awfulness called the Eagle Centre (seen here). In the first decade of the twenty-first century this too was swept away and replaced by Westfield (now Intu), which opened in 2008, drawing yet more shopping away from the historic heart of the city. The street itself has been much improved by good-quality new builds. (Photograph of 1974 by Raymond's Agency for the *Derby Trader*, Derby Museums Trust)

Opposite Albion Street is the Derby Co-op.

42. THE DERBY CO-OP

This is where the Derby Co-op, England's third such, founded in 1850, concentrated their stores. On the right is a block of 1911–17, designed by Alexander MacPherson, that still fulfils the role for which it was designed. On the left, a remarkably un-staid moderne store, designed in 1939 by Sydney Bailey after Bruno Paul's Sinn department store of 1928 in Gelsenkirchen, Germany. Work stopped in 1940, to be resumed only in 1949 and completed in 1953. An attempt to list it failed in 2012 when the Co-op closed it, but it has since, mercifully, found a new occupant. (Photograph by the Co-operative Society from David Boydell, *Centenary Story* (Manchester, 1950))

Continue along East Street to St Peter's Street.

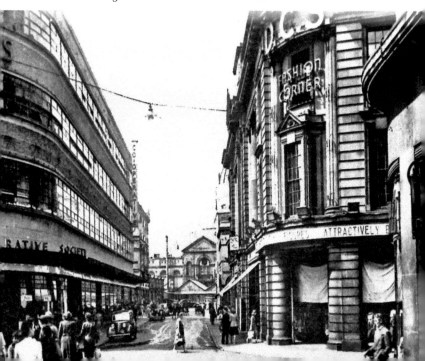

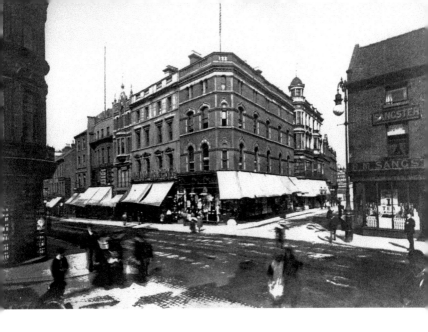

43. ST PETER'S CHURCH YARD

Halfway down St Peter's Street, East Street (centre right) and St Peter's Church Yard cross. On the north-east corner in *c.* 1900 once stood the Midland Drapery, then recently epically enlarged, but East Street was only widened in 1911 when the eighteenth-century building (right) was replaced by an ornately attractive branch of Boots. The great store closed in 1969 and was demolished to be replaced by the Audley Centre, a bland two-storey brick shopping arcade of dubious fiscal viability, and due to be replaced. (Photograph of *c.* 1900, possibly by Frank Scarratt)

Look up St Peter's Street.

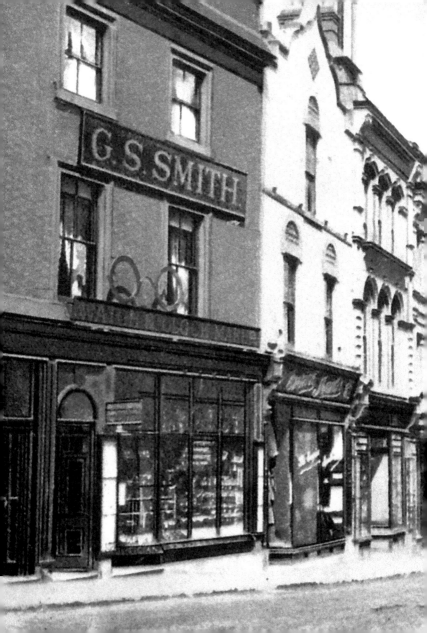

44. ST PETER'S STREET

The prehistoric trackway through Derby continues north from The Spot with St Peter's Street, named after the city's surviving original church with medieval fabric. There has been a great deal of piecemeal rebuilding to both sides during the twentieth century, most of it of poor quality. Losses have included the eighteenth-century house occupied by George Simon Smith, eldest son of John Smith, the clockmaker (*see* above, No. 15). In the middle distance on the right, note the horseshoe above the entrance to the Midland Drapery, set up to 'draw in' eager customers. The picture predates the 1904 electrification of the tramways. (Photograph from a colour printed postcard postmarked, 1905)

Look down St Peter's Street.

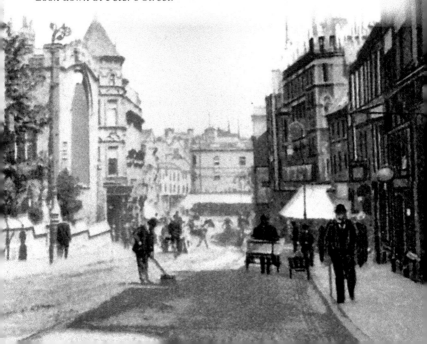

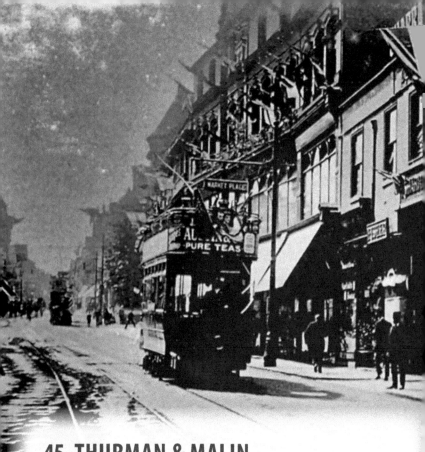

45. THURMAN & MALIN, ST PETER'S STREET

Much further down is this view taken looking up St Peter's Street, probably during the 1911 coronation celebrations, showing a decorated tramcar descending past Messrs Thurman & Malin's large drapery store opposite, and in competition with the Midland Drapery. Between it and Singer's was a building that gave through to Oakes's Yard where

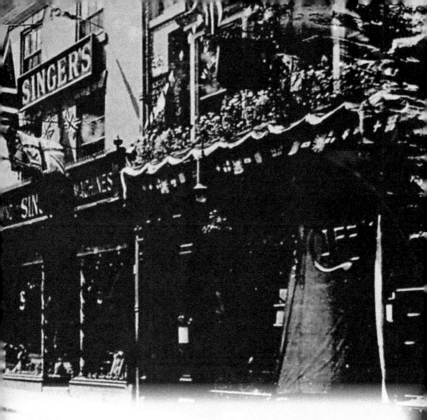

Robert Bakewell, England's greatest native-born ironsmith, had his works from 1712 to 1752, which is commemorated by a Civic Society blue plaque on the building's replacement – the gabled Yorkshire Bank of 1979. Unlike the Midland Drapery though, Thurman & Malin was converted for other uses when it eventually closed. The street was pedestrianised in 1990. (Print from an anonymous half-plate glass negative of 1911, private collection)

Proceed along St Peter's Church Yard to Green Lane, cross to Macklin Street and look back at the site.

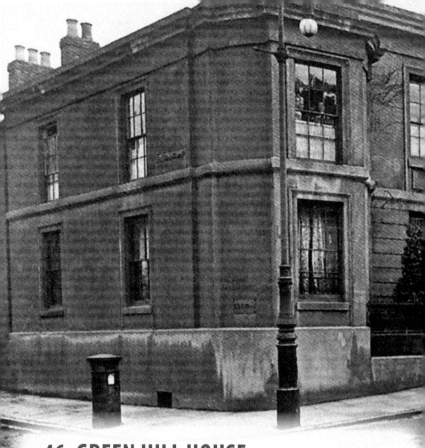

46. GREEN HILL HOUSE

The middle part of Green Lane was called Green Hill. On the east side, in complete contrast, stood Green Hill House, a stylish Regency villa built for high-flying lawyer Charles Clarke in 1825, probably to the designs of Derby amateur Alderman Richard Leaper (1759–1838). The property was later the home of opulent currier John Richardson of W. & J. Richardson, St Peter's Street, and in 1891 was acquired by memorable GP Dr George Sims. Here we see his gig awaiting

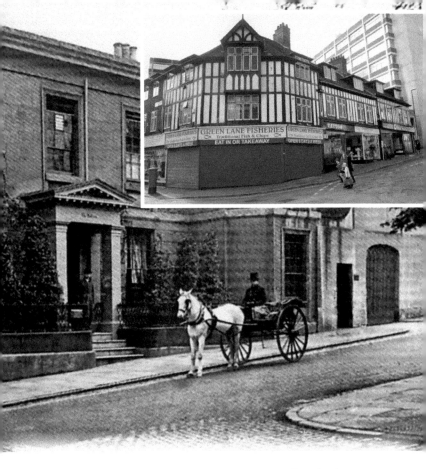

him outside the house in Edwardian times. On his death in 1925, it was rapidly destroyed for a bland row of shops designed in unimaginative neo-vernacular by John Wills Jr, whose offices were in St Peter's Church Yard opposite (inset). (Photograph of *c.* 1899/1904, private collection)

Descend Green Lane.

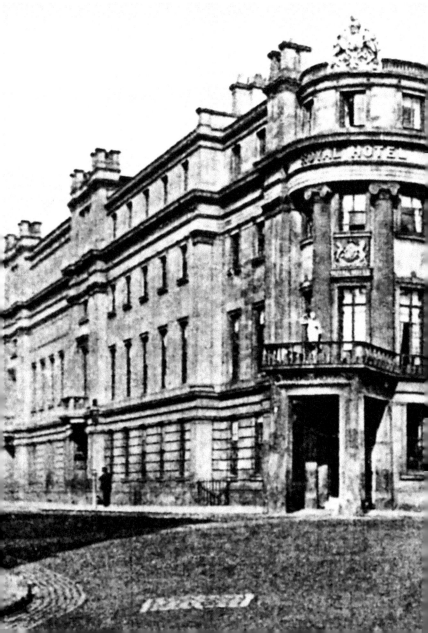

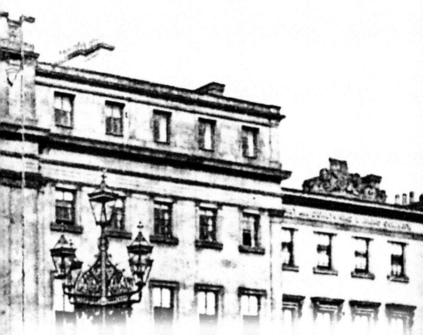

47. ROYAL HOTEL, VICTORIA STREET

In front of you is Derby's Grade II listed Royal Hotel, designed by Robert Wallace and built in 1839. Here we see it in the 1860s (as captured by Keene). It ceased to be a hotel in 1946 and was shorn of its cresting and portico, with its turn-of-the-century canopies simplified. Wallace also designed the Derby & Derbyshire Bank, adjacent in Corn Market (built in 1837/38 and Grade II listed). The elaborate 1840s gas lamp standard was moved to the junction of Duffield and Kedleston roads when electricity was introduced in 1893 (giving the name Five Lamps to the area), and finally went for scrap in the Second World War. (Private collection)

Cross Victoria Street and turn around to look towards St Peter's Street.

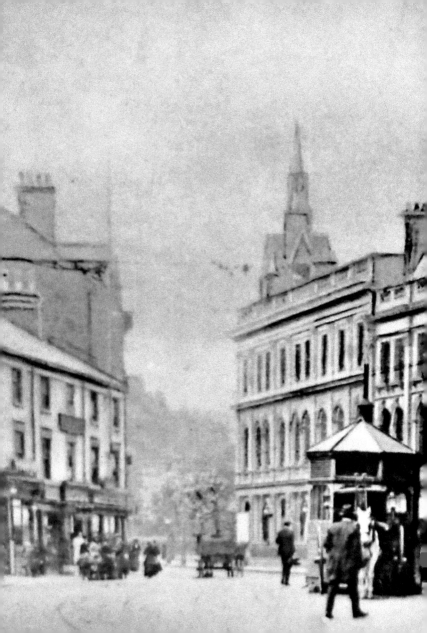

48. VICTORIA STREET

Originally, at the lower (north) end of St Peter's Street ran the Markeaton Brook, which one crossed on the Gaol (or St Peter's) Bridge. In 1839, this was lost beneath a culverted western portion of the brook, becoming Victoria Street, whereas it had previously been Brookside (essentially a path that ran alongside the brook, rather like Spalding or Wisbech, and was lined with fine eighteenth-century houses). On the north side of Victoria Street was built the Royal Hotel and the Athenaeum Club. In 1904 the Arts and Crafts Tramways' Offices (designed by John Ward and Grade II listed) were added, just visible to the right, and the Spotted Horse Hotel (later the Post Office Hotel) beyond that, founded in 1842 and rebuilt, as here, in 1872. The buildings in the centre date back to 1873 and are by Giles & Brookhouse (Grade II listed). Note the cabbies' rest (cf. No. 38). The street is now for buses and cabs only. (Photograph of 1905, from a postcard, private collection)

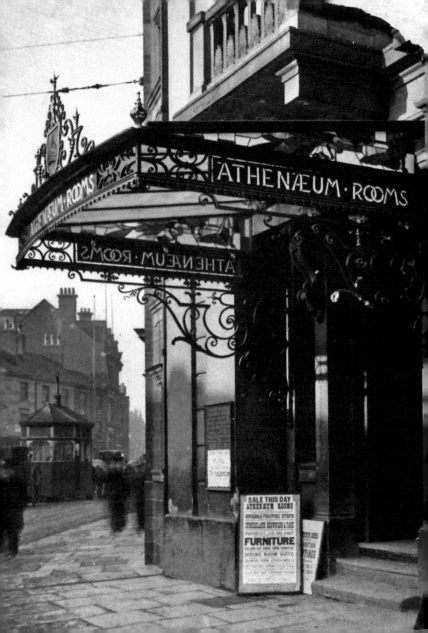

49. THE ATHENAEUM, VICTORIA STREET

The craftsmanship of Robert Bakewell was continued after his death by his foreman, Benjamin Yates, and then his son, William. The art was revived, in the teeth of competition from a vigorous cast-iron industry, in the 1850s by Alderman William Haslam, who was succeeded by his gifted son, Edwin. Edwin worked in Art and Crafts mode and exported his superb handiwork all over the country and empire. The Athenaeum was later provided by him, with a superb wrought-iron canopy over its entrance, as seen here. He also made similar ones for the whole façade, including the Royal Hotel. Today it has been moved and only the brackets partly survive after drastic modification in the 1940s. The entrance is now a nail parlour. (Photograph taken by Edwin Haslam when new, *c.* 1910, Derby Museums Trust L1265)

50. ALLSOPP'S HOUSE, THE WARDWICK

The Wardwick was once a small settlement close to Saxon Derby, but by the twelfth century it had been absorbed by Derby, although the name survives as a street. By the late seventeenth century it was lined with fashionable houses including this superb residence built for Thomas Allsopp in the latest parapetted style in 1708. The first-floor rooms are enfiladed and oak panelled. Allsopp's family went on to be big brewers at Burton, later ennobled as Lords Hindlip. The house passed to a series of Derby brewers, going in the 1920s to Burton brewers Samuel Allsopp & Co., ironically the firm founded by the descendants of the man who had built the house in the first place. They opened it as a pub in 1969 (which is currently closed at the time of writing). (Photograph of *c.* 1933)

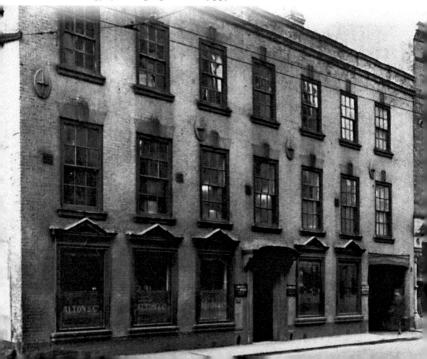